SKIPTON
HISTORY TOUR

First published 2022

Amberley Publishing
The Hill, Stroud,
Gloucestershire, GL5 4EP
www.amberley-books.com

Copyright © Peter Ellwood, 2022
Map contains Ordnance Survey data
© Crown copyright and database
right [2022]

The right of Peter Ellwood to
be identified as the Author of this work
has been asserted in accordance with
the Copyrights, Designs and Patents
Act 1988.

ISBN 978 1 3981 0253 8 (print)
ISBN 978 1 3981 0254 5 (ebook)

British Library Cataloguing in
Publication Data.
A catalogue record for this book is
available from the British Library.

Origination by Amberley Publishing.
Printed in Great Britain.

INTRODUCTION

In 2017, Skipton's profile was raised suddenly by the British media when official figures rated Skipton as the happiest place to live in the UK. Often dubbed the 'Gateway to the Dales' and situated amid the hills of Craven, Skipton is located in the Aire Gap, separating the limestone dales to the north from the gritstone moors to the south. Its history has given rise to a town with great heritage and a central High Street which forms an attractive backbone to this 'Happy' town.

While the Romans passed through Skipton, it was the Saxons who settled in the seventh century and gave the town its name, 'Scep-tun' or 'Sheeptown'. At the time of Domesday, William I granted the 'Honour' of this 'waste land' to Robert de Romille, a Norman baron after whom 'Rombalds Moor' is named. In 1090, De Romille built a castle on the crag overlooking what is now the High Street. By 1309 the castle had passed to the Clifford family and became their residence for more than 300 years. Rebuilt after the Civil War, much of the present structure dates from the 1650s. It is regarded by some historians as one of the best-preserved medieval castles in the country.

By 1204, Skipton had been granted its charter by King John to hold a market every Saturday throughout the year and the town grew around the marketplace, expanding along what is now the familiar gently sloping High Street. With a long-established livestock market,

Skipton became an important wool-trading centre and by 1800 handloom weaving was an important industry.

The arrival of the Leeds and Liverpool Canal in 1773, followed by the main lines of the London, Midland & Scottish Railway, brought further industrial growth to Skipton, with cloth making becoming a major activity. Textile production really took off after 1850, as did the population, which rose from 4,842 in 1831 to 12,977 in 1911, when textile production was at its height. Today, Skipton has a population of around 15,000 and while the textiles industry is long gone, the town continues to thrive.

In Skipton today there appears to be a resurgence of interest in the town's history, propagated through both traditional sources and more recently through social media platforms. Many of the town's pubs and shops proudly display 'Old Skipton' photographs and there is a rich source of history to be found by wandering around the main streets and ginnels. In this book, I hope I have given you a small snapshot of Skipton in times gone by and provided a useful pocket guide on which to base your first tour.

KEY

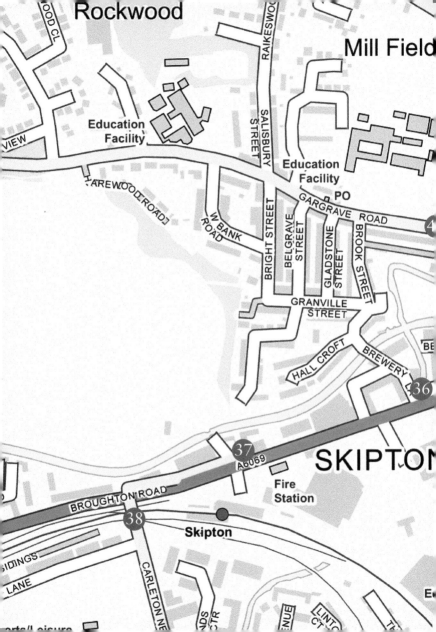

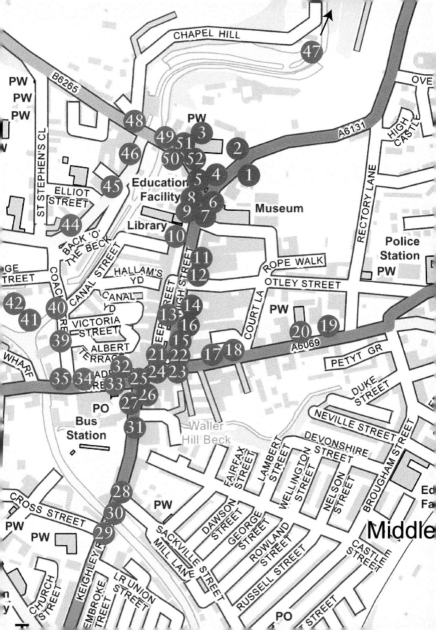

1. SKIPTON HIGH STREET AERIAL

Most of the old photographs on this tour were taken from locations visible on this aerial photo of the High Street, taken by Ken Ellwood in 2004. At the top of arguably one of the most impressive high streets in the country stands Holy Trinity Church, flanked by the superbly preserved Skipton Castle. The central High Street forms the backbone of the town and the main structure of the High Street seen from above has changed little during the last hundred years or so.

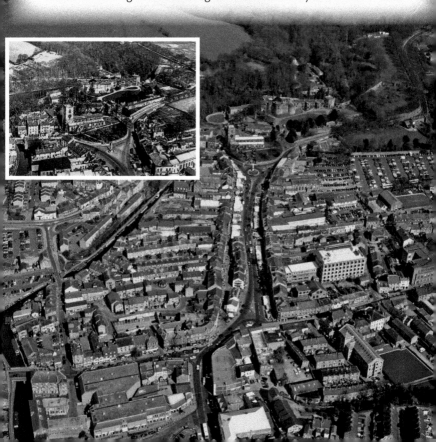

2. SKIPTON CASTLE GATEHOUSE

The logical place to start any tour of Skipton is at the castle entrance, and if you are a visitor to Skipton for the first time a trip round the castle should be high on your itinerary of places to visit. The original castle was built in the late eleventh century by Robert de Romille, a Norman baron who built a motte-and-bailey castle on a crag high above Eller Beck, and established this stronghold overlooking the Aire Gap, at the top of which is now Skipton's main High Street.

This 1978 photo shows the Skipton Brass Band posing in front of the gatehouse for the cover shot of their LP, *Skipton Band*.

Of interest on the inset photo is this 1906 De Dion-Bouton automobile, believed to be the first car in Skipton. Standing alongside is Mr George Smith, who drove for Dr Liversedge. George later became lorry driver for Skipton Council.

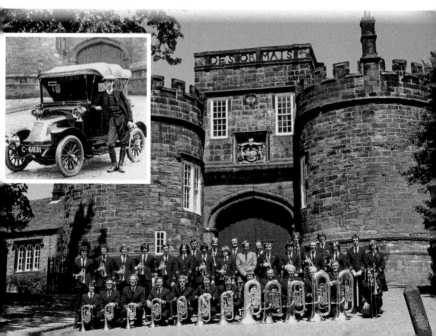

3. SKIPTON CASTLE

This view taken from the church tower shows how little has changed to the main layout and fabric of Skipton Castle since the inset photo was produced. The impressive fortified gatehouse on the right was originally built under the ownership of Robert de Clifford, who was granted the property by Edward II in 1310 and was appointed Lord Clifford of Skipton and Guardian of Craven. Robert Clifford ordered many improvements to the fortifications but died at the Battle of Bannockburn in 1314 with his improvements barely complete. The gatehouse we see today is reputed to have been 'restored and rebuilt' early in the seventeenth century, the work of the 5th Earl of Cumberland, the 'architect earl' as he is often called. During the

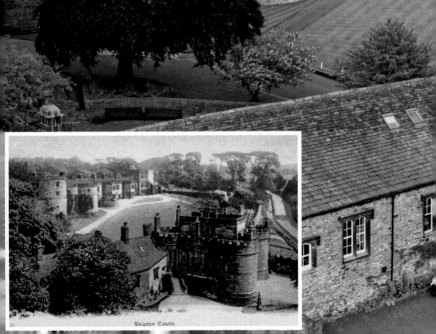

Skipton Castle

Civil War (1642–51), the castle was the last Royalist bastion in the North, only surrendering after a three-year siege in 1645. 'Slighted' under the orders of Cromwell, the castle was skilfully restored by the redoubtable Lady Anne Clifford. After the siege, she ordered repairs and to commemorate this planted a yew tree in the central Conduit Courtyard. Skipton remained the Cliffords' principal seat until 1676. The main castle buildings can be seen behind the gatehouse and the road up the bailey, heading out of town, can be seen on the right, now obscured by trees in the current view. The gatehouse bears the Cliffords' Norman-French motto '*Desormais*', meaning 'Henceforth!'

4. HOLY TRINITY CHURCH

At the head of the High Street is the parish church of the Holy Trinity. This building, like its neighbouring castle, has been modified, extended and refurbished over the centuries and suffered bombardment during the Civil War. It has also suffered the natural hazards of fire and lightning, the last of which occurred in 1925, causing the destruction of the organ and damage to the roof. The clock was installed before 1803 and the porch was added in 1866. Inside the church there are

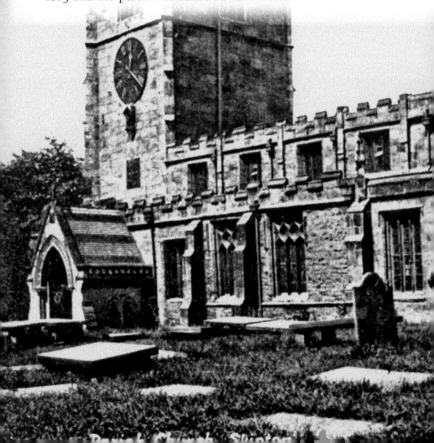

numerous Clifford family memorials dating from the sixteenth and seventeenth centuries, including the impressive Clifford tombs.

This old photo shows the front churchyard with tombstones in place. The current churchyard, with its beautifully tended lawns, shrubs and plants, dates back to 1945 when it was agreed jointly by the Skipton UDC and the church to remove the gravestones from the front of the church to form a terrace at the back.

5. TOP OF THE HIGH STREET

Once you have established your bearings in the churchyard at the top of the High Street, take time to look down it and imagine what it might have looked like 100 years ago. In this image, Sir Matthew Wilson stands proudly on his plinth surveying the top of a busy High Street. An early motor car moving slowly up the High Street passes a horse-drawn carriage, while a gentleman smokes his pipe in the foreground, no doubt curious about the photographer. Note the raised cobbled path on the left, which comes from the old vicarage, part of which can still be seen today just in front of Wildwood

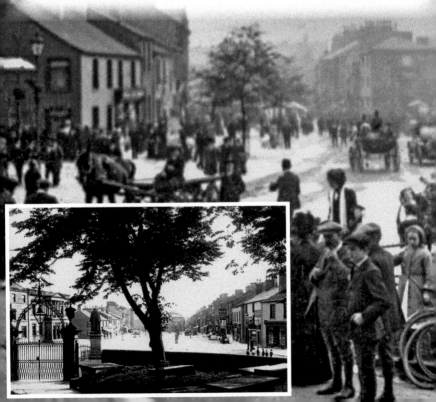

restaurant. In the inset photo, a beautiful gas lamp is suspended from an arch-shaped church gate and the gravestones are still present. Compare these gates with the current gates, which were erected in memory of the popular Dr Fisher.

Sir Matthew Wilson, of Eshton Hall, was Skipton's first MP and this statue was unveiled by the Marquis of Ripon in 1888. It was unusual then for a statue to be erected during anyone's own lifetime, as happened in this case. The statue was later moved in 1921 by B. B. Kirk, builder and contractor of Waller Hill, to a position in front of the library to make way for the new cenotaph.

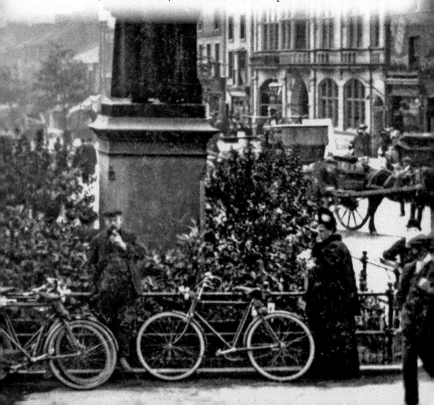

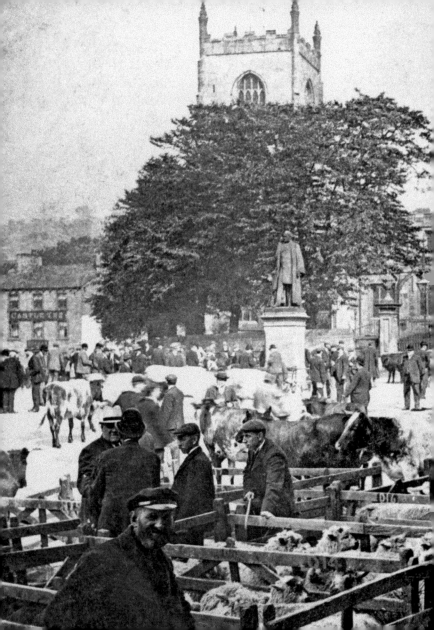

6. THE CATTLE FAIR

Before we move on to the Town Hall, have a look back at the church gate from where we have just walked. This 1905 photo of the cattle fair at the top of the High Street is full of atmosphere. The cattle are loose while the sheep are kept in pens. Members of the farming community chat, while in the foreground some interested characters spectate as Skipton photographer John Smith takes this classic photo. The Castle Inn is clearly visible on the left and after such cattle markets the many public houses on Skipton's High Street would be full and doing good business.

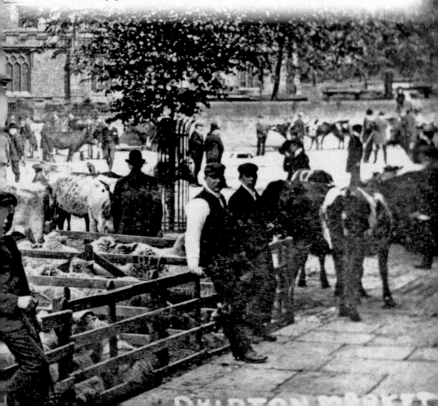

7. THE TOWN HALL

Skipton Town Hall was built in 1862, on the site of the former vicarage of Holy Trinity Church. It was originally built in 1895 as a private venture by the Skipton Building Company and later bought by the then newly created Urban District Council, replacing the 'Old Town Hall' on Sheep Street.

In this image we can see the Town Hall decorated for the King George V's coronation in 1911. The decorative canopy of glass and wrought iron was added at the end of the nineteenth century. This was later demolished during the 1950s.

On the left-hand side of the Town Hall, there is a plaque dedicated in memory of a gifted aircraft designer, Herbert Smith, who was born in Bradley in 1889. He designed all of Sopwith's fighting aircraft, such as the Camel, Triplane and Snipe, used by the Royal Flying Corps during the First World War.

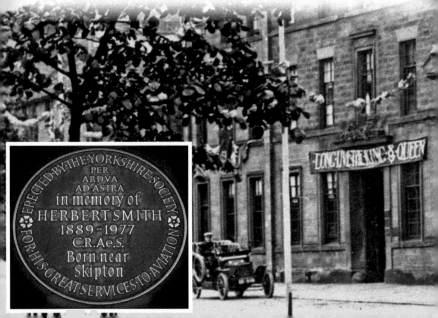

Also located in the Town Hall is the council chamber where for over 100 years councils have held meetings; a particular point of interest in the chamber are the benches and chairs which were made by the legendary furniture maker Robert 'Mouseman' Thompson.

To the left, behind the lime tree, is a row of Georgian cottages, demolished in September 1963 to make way for a new health centre. The plans to build the health centre were controversial from the start and on completion in May 1965 soon had the reputation for being Skipton's ugliest building. The health centre closed in 1990, with the building playing temporary host to a number of agencies before finally being demolished in 2014. The current building housing Pizza Express and Chevin Cycles is arguably a minor improvement to an important part of the High Street.

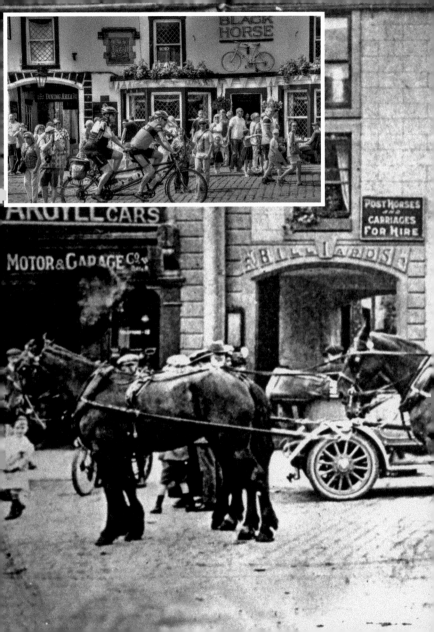

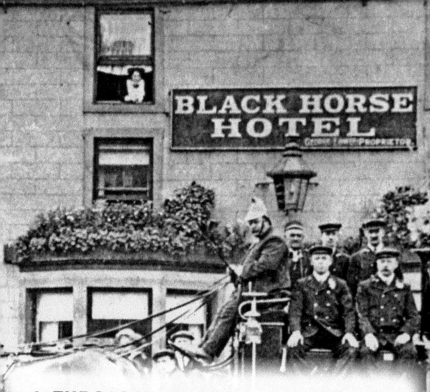

8. THE BLACK HORSE

In this image we can see the horse-drawn steam fire engine and one of the housemaids peering out the middle window. 'Billiards' is advertised above the arched entrance. It is reputed that this ancient hostelry was formerly a royal mews of Richard III, 1476–85, when he was Lord of the Castle and Honour of Skipton. Outside a sign above a mounting block recalls 'how a local tradition during the civil war, when Skipton Castle was the last Royalist stronghold in Yorkshire to surrender to the Roundheads, a troop of Cromwell's soldiers arrived and were served poisoned ale'. Some locals may say that back in the 1980s, they still did!

9. SCHOOL TRIP

Just down from the Black Horse, we can see this view towards the Red Lion, one of Skipton's oldest inns and reputed to be the former hospital of St Mary Magdalene, a leper hospital from 1310–50.

In this charming photograph eight charabancs packed full of children are going on a school trip and they know they are being photographed! In the background, a Model T Ford is parked in front of the Red Lion and further to the left, Dobson's Chemist, and the corner of Jerry Croft, still not occupied by Whitakers Café, who moved there in 1926.

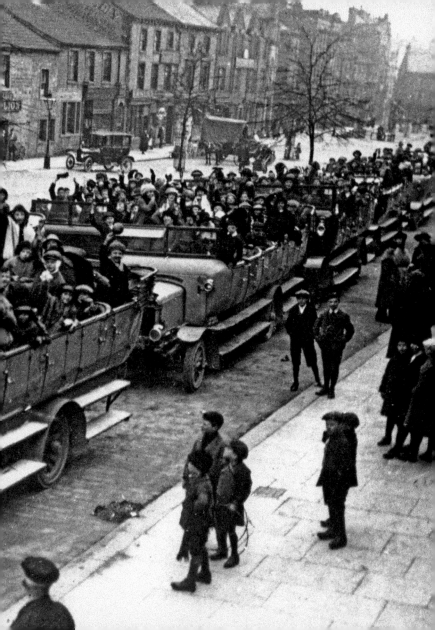

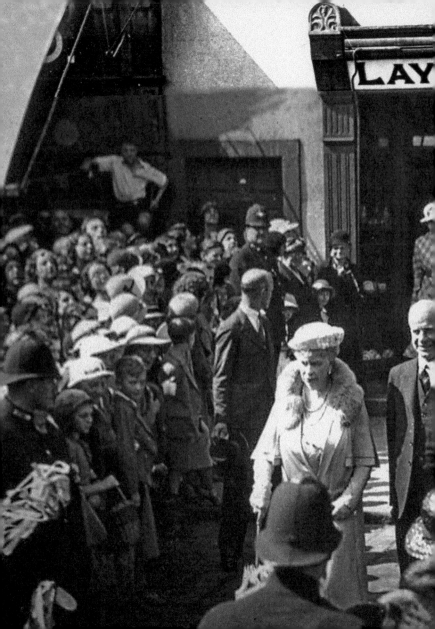

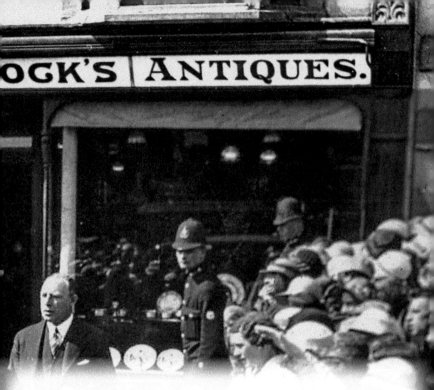

OGK'S | ANTIQUES.

10. QUEEN MARY

Queen Mary had a great love of antiques and whenever she stayed at Harewood House with her daughter, Mary, Princess Royal and Countess of Harewood, she enjoyed visiting the most important dealers in the vicinity. Mr Laycock had a tremendous reputation in the world of antiques, as shown by the visit of Queen Mary to his shop on the High Street in about 1930. The premises are currently occupied by 'Trespass' the outdoor shop and can be identified by the windowsills above the sign and corner stones on the right-hand side. The gentleman at the top left seems to have found a good vantage point from which to view proceedings!

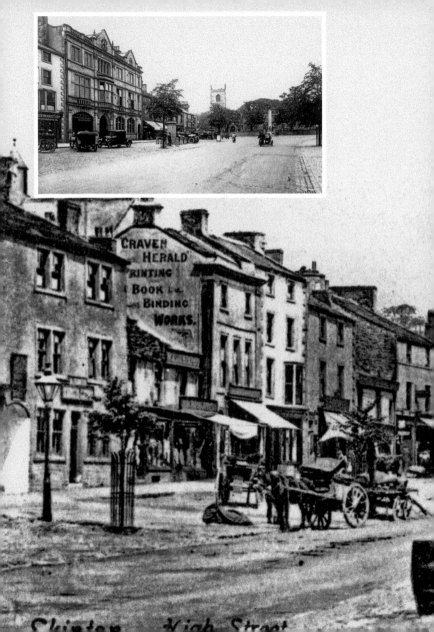

Skipton High Street

11. SKIPTON HIGH STREET

Laycocks, from where we've come, can be seen to the right of the awning and the Craven Herald is to the left on this photo, which was taken at 11.16 a.m. The gas lamps and the young lime trees, which were planted in 1897, indicate that this picture was taken c. 1900. Skipton Library is not yet built in this scene, but to the right of the bay window you can clearly see the two premises that were demolished to make way for the new library, which was opened on 16 February 1910 by Sir Mathew Wilson. On the later 1920s photograph (inset), the Skipton cenotaph is in position and the statue of Sir Mathew Wilson is now in his new position in front of the library but slightly obscured by the maturing lime trees. On the left, the Kings Arms is situated next to the Bay Horse yard but was demolished in the 1960s to make way for shops. The space is now occupied by everyone's favourite jean shop – 'Just Jeans'. The rebuilt yard continues to provide easy pedestrian access to Canal Street and some peace away from the busy High Street.

12. FRED MANBY & BRO.

This wonderful old photograph of an instantly recognisable part of the High Street shows Fred Manby and Bro. Ironmongers, which was the oldest known family business on the High Street, established in 1817. Lower down this row of buildings, known as Middle Row, is another of Skipton's expired inns: the Fountain Inn, which lost its licence in 1907, probably due to closure of the High Street cattle market. One of its former landlords was a J. Hallam, who, when he opened its doors, said 'The gates of infamy are now opened'. He was a fiddler and left directions that when he died, there was to be no ceremony but they had only to play 'Bundle and Go', a traditional Irish jig. The Manby's clock above the sign was installed on 20 May 1912 and is still ticking today. Sadly, Manby's ceased trading in 1986 after nearly 170 years of business. There was always a fine display of ironmongery in the front window and some may even remember a display of shotguns and the cellar, which was like an Aladdin's cave of all kinds of stuff!

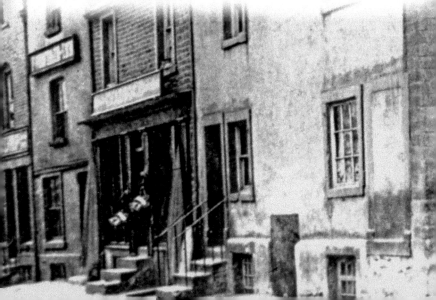

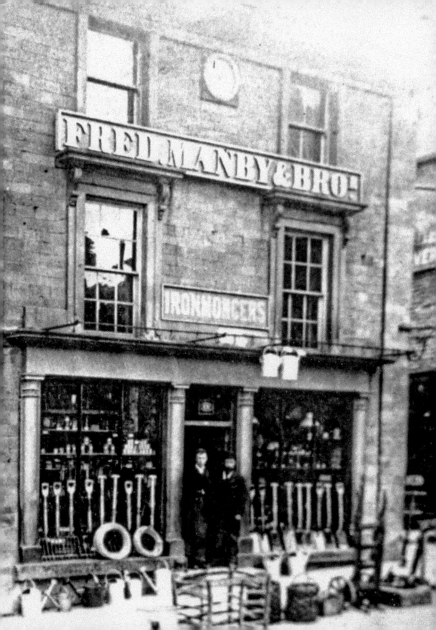

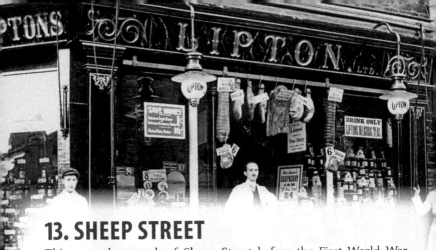

13. SHEEP STREET

This 1914 photograph of Sheep Street before the First World War shows it has remained largely unaltered. The cobbled street is split off from the High Street by Middle Row. This was an era when shopkeepers proudly displayed their goods, as illustrated by Lipton the grocer, with a mouth-watering selection of fare. Just before Lipton's was Forts, the drapers shop, which remained a ladies outfitters after 1947 when it was sold to Mr Atkinson of Leeds. It later became Greenwoods and is now Costa Coffee, one of Skipton's many shops specialising in the sale of this widely consumed stimulant!

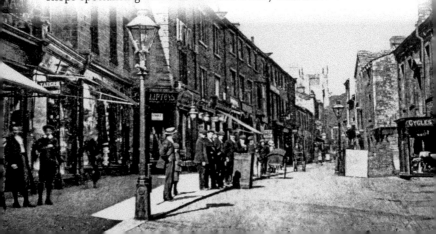

14. SKIPTON HOSPITAL GALA

The first Skipton Hospital Gala took place on 13 June 1901, starting on the brick buildings off Bailey Road. There is a splendid float representing Dewhurst's Sewing Cotton and a large bobbin is hauled by one of the company's cart horses. The Hospital Gala attracted huge crowds from all around the area and extra train services were put on to accommodate this popular annual event. Note the smart Edwardian clothing worn by all. The Fountain Inn is flanked on the left by Mr Crump, chemist and druggist, and on the right by Chaddock's, saddler. In those days you could have a tooth extracted by Mr Crump, who invariably counselled his patient to nip into the pub next door and have a rum, which he regarded as a first-class mouthwash!

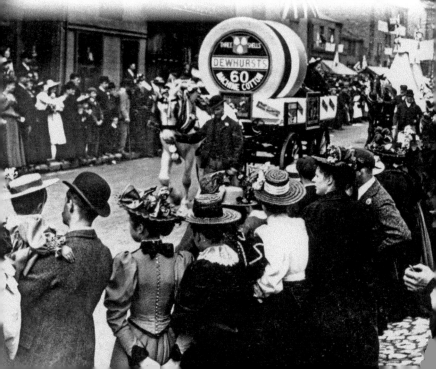

15. SKIPTON SHOW, 1870

This is the earliest known photograph of the High Street, on the occasion of the Skipton Show in 1870, an annual Craven Agricultural Show that was held from 1855 to 1929.

The Barclays Bank building, formerly Martins Bank Ltd, can be seen on the right but the Midland Bank building (1888), now HSBC, has not been built yet. On the corner of Middle Row, William Smith had succeeded his father's painting, plumbing and glazing business, which continued until 1880, when the firm moved to Court Lane and William Mattock took over this shop for his corn merchant's business. The shop has passed through numerous hands: Mr Harry Mattock, Mr J. G. Mattock, the County of York Agricultural Co-op, A. J. Clayton, George Leatt, Roy Marlour, the Edinburgh Woollen Mill and now 'The Snug'.

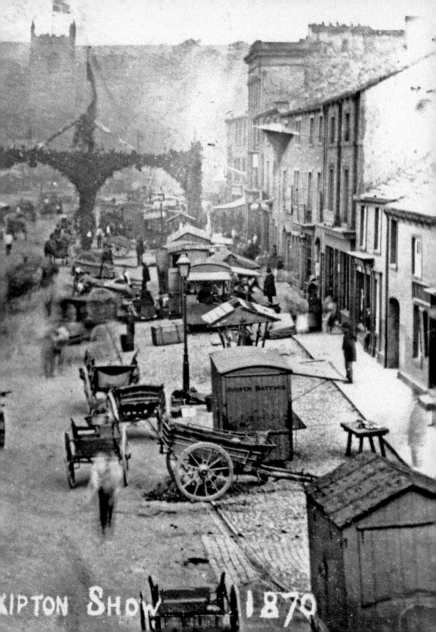

KIPTON SHOW 1870

16. SKIPTON CATTLE MARKET

This photograph, taken from a similar vantage as the previous page, can be dated by the fact that the Midland Bank, seen here on the right (HSBC), was built in 1888. The exchange buildings on the left were built after 1895 and the small lime trees present on the right were planted in 1897 for Queen Victoria's Diamond Jubilee and before 1908 when the Wheatsheaf Inn next door closed its doors. The fortnightly cattle fair was eventually moved to Jerry Croft, now the car park behind the Town Hall. Dr G. Rowley, who was a prominent Skipton historian, said that there were thirty years of argument about it. The final Cattle Market held on the High Street took place on 28 May 1906 and within two years of it moving, the High Street had lost three

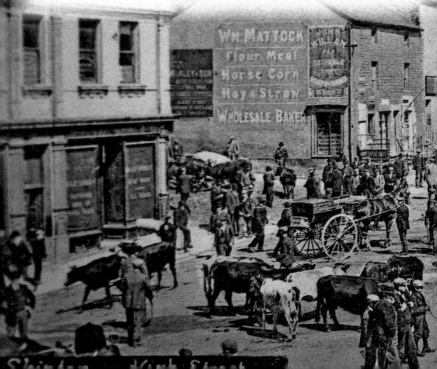

of its inns: The Thanet's Arms, the Fountain and the Wheatsheaf. The majority view at the time was that the Cattle Market had had its day and most townsfolk regarded it as a thoroughly unpleasant nuisance. It wasn't until the 1930s that trading cattle by private 'haggling' was a dying habit and by the First World War, when the Jerry Croft site was taken over by the army, the Cattle Mart Company finally merged with the Auction Mart Company, which had continued on Broughton Road. The 'Old' Auction Mart, now occupied by Morrison's, moved to its current site on the western bypass in 1990 and so ended the close association of the town's High Street with the farming community.

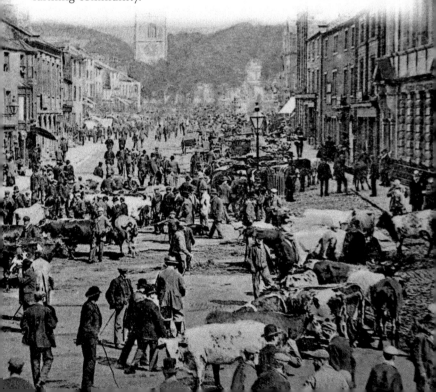

17. NEWMARKET STREET (WEST)

Before we head across Caroline Square, turn left at the end of the High Street and walk a short distance towards the Tool Box. On the left-hand side of Newmarket Street, the building that is now Saks hairdressing salon was once the premises of T. L. Frearson, ironmongers, from 1899. A few 'older' members of our community will remember this shop along with Manby Bros as a wonderful emporium. The Skipton Building Society once occupied the adjoining building towards the right of this picture having moved into the premises in 1892. It was established some thirty-nine years after a public meeting at the Town Hall by Samuel Farey and George Kendall, who were well-known wealthy industrialists who had prospered from the Industrial Revolution. It is now the UK's fourth largest building society and proudly uses the Skipton Castle gatehouse as its instantly recognisable logo.

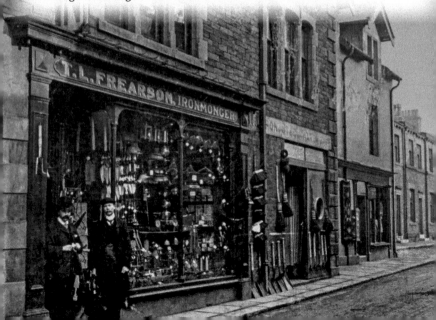

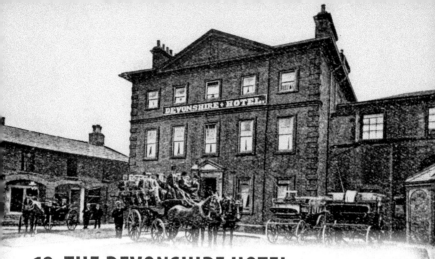

18. THE DEVONSHIRE HOTEL

This wonderful old photograph shows the Devonshire Hotel *c.* 1910 when it provided accommodation for stagecoach travellers. The original inn was built sometime in the 1780s when Newmarket Street was part of an unmade road to Otley. Designed by the Earl of Burlington, it was known as the 'New Inn' until the 1820s. The name change to the Devonshire Hotel occurred in 1811 after the death of the 5th Duke. I wonder what the coach travellers would have thought about the gentleman sweeping down Newmarket Street on his Segway in this recent colour photograph.

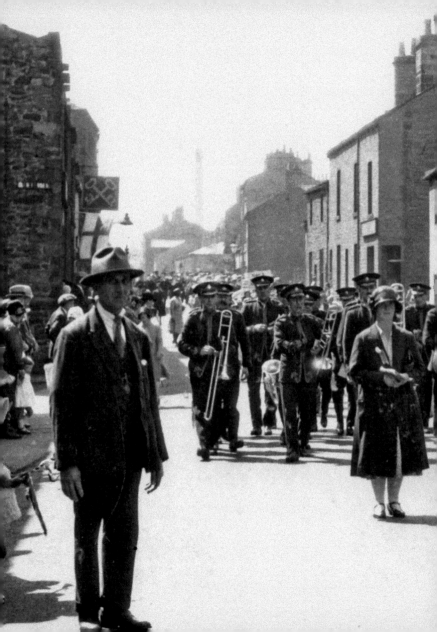

19. NEWMARKET STREET (EAST)

A view of Newmarket Street that few people in Skipton will now recognise. The Skipton Prize Band lead a parade as the conductor slows the band down for this 1920s photograph. The original Cross Keys is situated on the left opposite the fish and chip shop, which was previously the Nags Head. This property was sold in 1910 for £405 to Mrs H. Watson and Mr W. A. Simpson. Mr Brown's fish and chip shop moved there in 1915, and the 'Nags Head Fisheries' remained until the building was demolished in 1960. The buildings on both sides have long been demolished except for the few adjacent to Court Lane in the distance. The profile of White Rose Insurance solutions can be seen marking the position of Court Lane to the right.

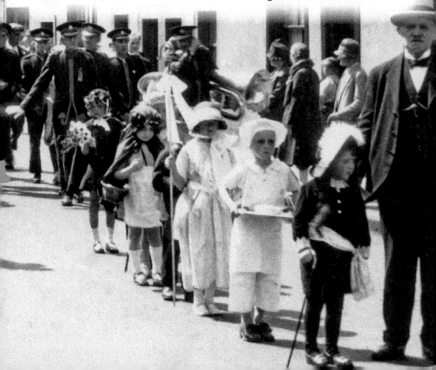

20. ST ANDREW'S CHURCH

St Andrew's Church, architecturally speaking, is one of Skipton's finest buildings. On 19 September 2014, it celebrated its 100th anniversary and the main photograph shows John Edward Gaunt, Mrs A. Gunnell, John Harrison and eighty-four-year-old Thomas Henry Dewhurst laying the inscribed memorial stones of the church to commemorate the start of its construction. The new church was designed by James Totty of Rotherham and was to be built in late Gothic style using Eastburn and Ancaster stone. At the time the foundation stones were laid the First World War had been in progress for just over six weeks.

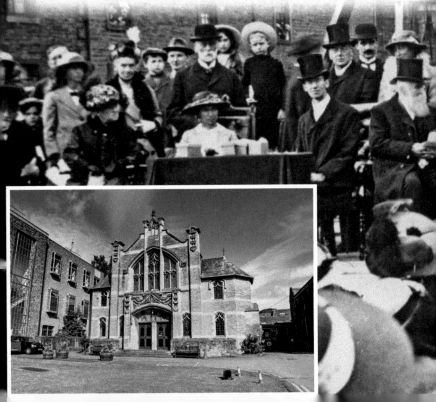

This would have a significant impact on funding and decimate its male membership to just forty-two when the church finally opened for business in 1916. In the years that followed congregationalism suffered the slow decline as experienced by other Nonconformist denominations at the time. The church is now a local partnership of the United Reformed Church and the Methodist Church, where members of the two traditions share in worship, fellowship, service and mission.

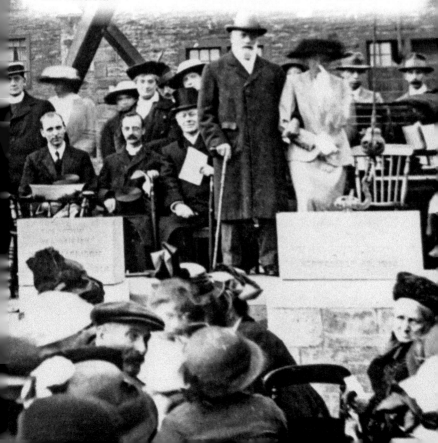

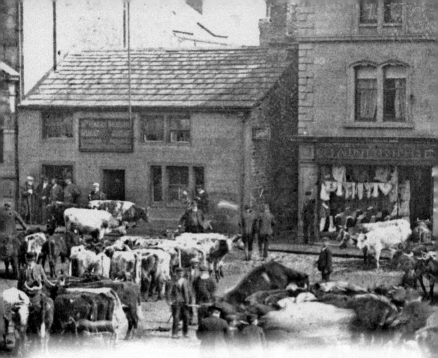

21. FATTORINI CORNER

One of the last cattle fairs to take place on the High Street was in the spring of 1906. Here we are standing on a cart looking across to Fattorini Corner on the right, H. Brown & Sons, the grocers (1916), Mr R. P Bainbridge, the drapers, and on the left the Wheatsheaf Inn, which closed its doors in 1908, now the site of the Halifax Building Society.

The original building at the corner of Newmarket Street was erected in 1863 by Baldisaro Porri for his son-in-law, Mr Innocent Fattorini's, the jeweller. He modernised this part of the High Street in 1895 and to this day it is still one of the finest buildings on the High Street. This now forms part of High Street House and you can easily see that the stonemasonry on the upper floors are a lighter tone.

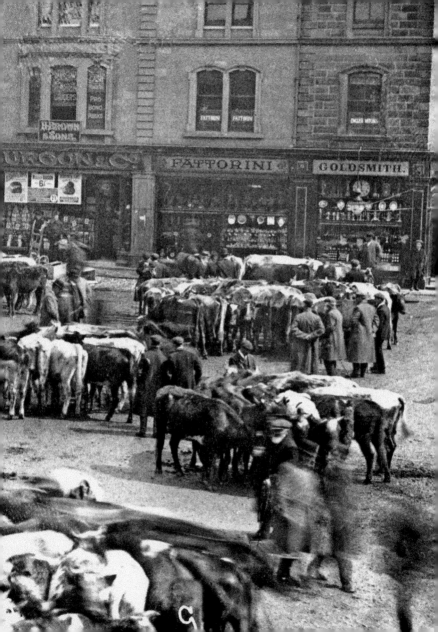

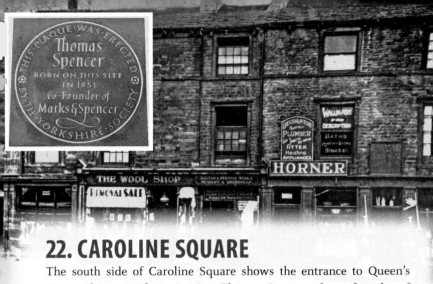

22. CAROLINE SQUARE

The south side of Caroline Square shows the entrance to Queen's Court. This was where, in 1851, Thomas Spencer, the co-founder of Marks and Spencer, was born and where a commemorative plaque can be seen between Savers and the Yorkshire Trading Company. The Horner business was at this shop from 1891 to 1973, which is now occupied by Betfred. The 1960s colour photograph shows the Horner business seventy years later. The Craven Arms pub can be seen in the background advertising Hammond Ales.

23. CAROLINE SQUARE

A well-known view of the Cattle Market in Caroline Square spilling out into the junction of Swadford Street and Keighley Road, possibly taken from the bay window currently occupied by the British Heart Foundation shop. Saddler Wilson's shop was later occupied by Barclays Bank and my father, Ken Ellwood, took over Brian Hargreaves' Dental Practice above the bank in 1961, remaining there until 1986. The Brick Hall Hotel, a popular watering hole on market days, can be seen on the right and further over the premises of Mr John Henry Hartley, who in 1897 advertised this shop as 'probably the oldest drapery establishment in Skipton'. By 1893, he had replaced the small bay windows with large plate glass windows in order to improve the shop display. There were many photographs taken of the Cattle Market during this period as the days of holding cattle fairs on Skipton High Street were finally coming to an end.

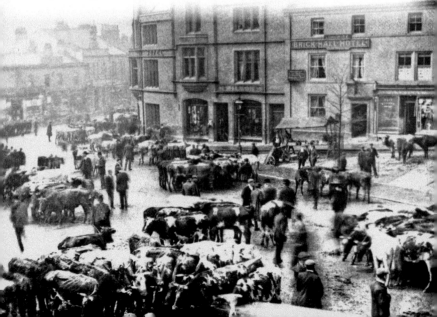

24. CORONATION ARCHWAY

As we move from Caroline Square towards the junctions of Keighley Road and Swadford Street, we can see in this photograph the arch, which was erected to celebrate the coronation of George V in 1911. Through the archway are shops converted from the old Christ Church Vicarage. The corner building called Central Buildings (Altham Ltd tea merchant in this photograph) is currently 'The Barber Shop', which features a nice display of Skipton old photographs on its walls. The gentleman with the beard at the front of the crowd is Moses Brocklesby, who had a shop near to Fattorini's. He was a Wesleyan Methodist preacher who lived above the shop. Note also the child in the middle with a hoop and stick, a popular toy during this period.

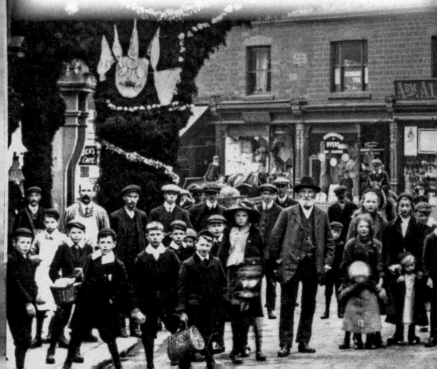

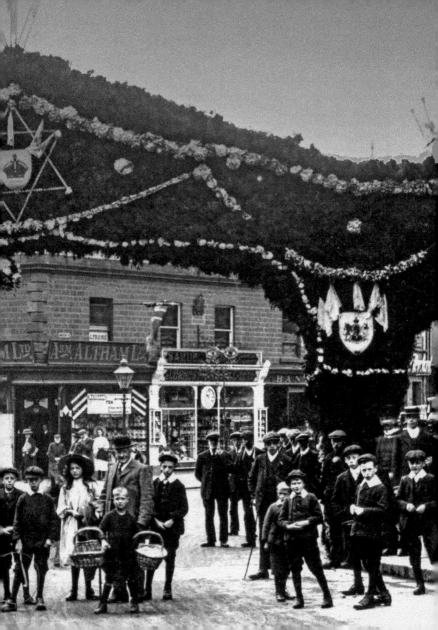

25. CHRIST CHURCH VICARAGE

Christ Church Vicarage was erected on land given by Skipton parish church for the development of the new Christ Church and was built in 1837. The line of the railings around the vicarage can still be found on the pavement today. To the right of the vicarage is the old tithe barn, which in its later years was used by travelling salesmen and showmen. It was demolished in 1901 to make way for Mr R. A. Stockdale's Wine and Spirit Lodge. The vicarage was converted in 1901 to a block of shops, now known as Central Buildings.

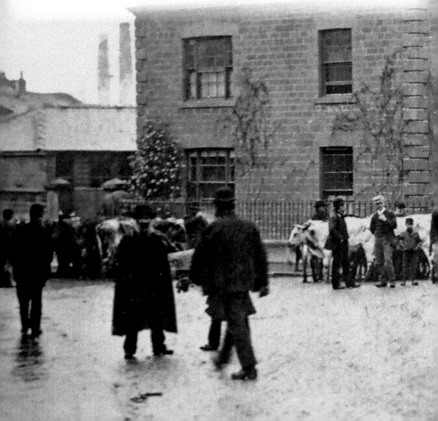

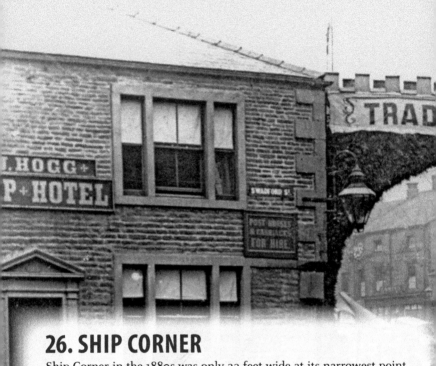

26. SHIP CORNER

Ship Corner in the 1880s was only 23 feet wide at its narrowest point. The arch was erected annually in celebration of the Craven Agricultural Society's Show. The building on the right housed Skipton Post Office and all the buildings seen through the arch on the High Street are all now demolished. James Hogg was the landlord of the Ship Hotel from 1874 to 1885 and in 1886 Francis Addyman was the last landlord of the Ship Hotel before it was demolished in the road widening scheme started in 1887. The 1920s inset photograph shows Ship Corner from a similar view point and the effect the road widening had on this part of the town. The rebuilt Ship Hotel was a residential hotel until its closure in 1924.

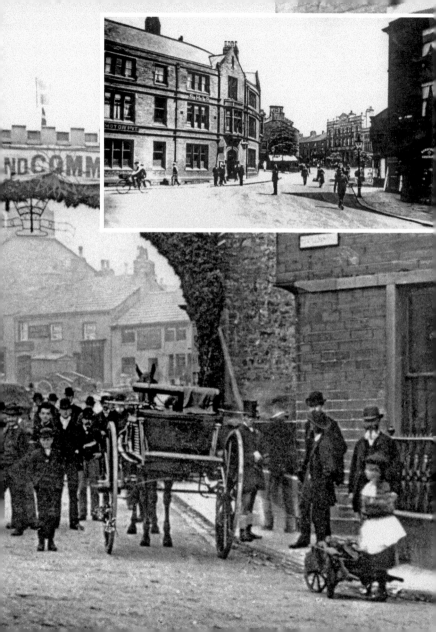

27. KEIGHLEY ROAD

Looking south along Keighley Road the two carts show the narrow point of the road due to the position of the old Unicorn Hotel. This part of Skipton was not widened until the 1920s. Lawrence the Draper is situated at the entrance to Waller Hill, now the entrance to the bus station. In the background the Liberal Club, now Craven Hall, is a recognisable feature on the corner of Sackville Street and the wall on the left is part of the bridge that ran over Waller Hill Beck.

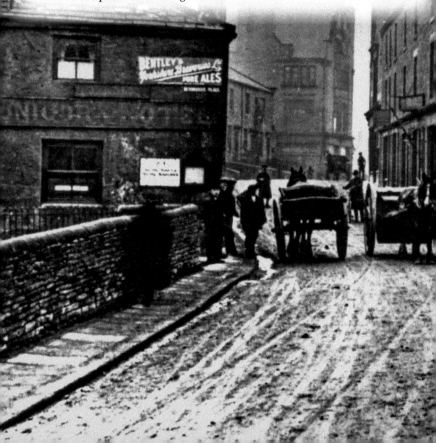

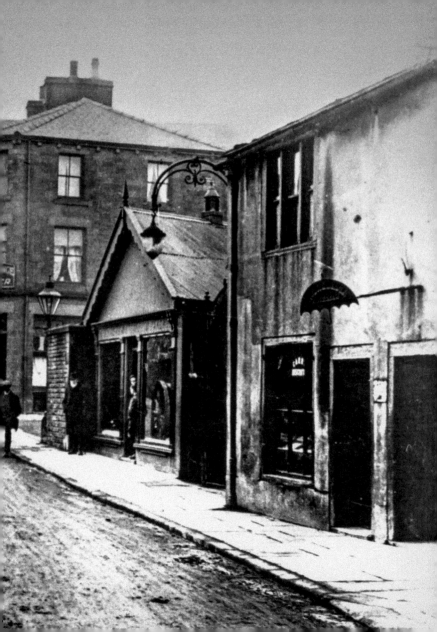

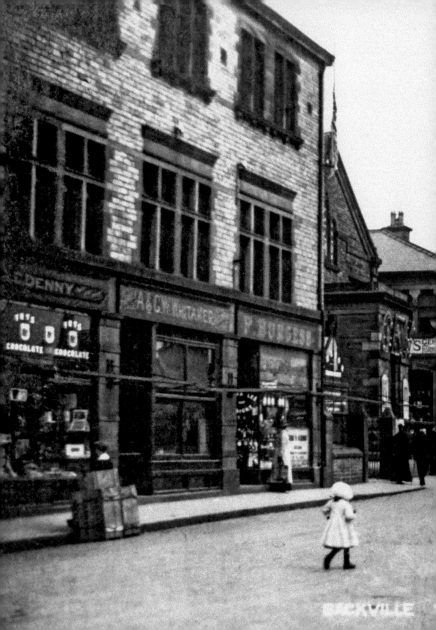

28. SACKVILLE STREET

From Ship Corner we can walk along Keighley Road until we arrive at Sackville Street, a most distinctive street in the town, as illustrated by this Turner series postcard. Outside the Temperance Hall, which is where the Plaza Cinema now stands, is a group of smartly dressed elders whilst children play in the street. This photograph was taken in about 1905, some years before the Temperance Hall was converted to a cinema in 1912 by the new owner Mr Mark H. Morris. The Gem Cinema, as it was called, was eventually reopened as the Plaza Cinema in 1928, allowing Morris to pursue his venture in developing the Keighley Road site where in 1929 the 'Morriseum' opened and within a year was renamed the Regal.

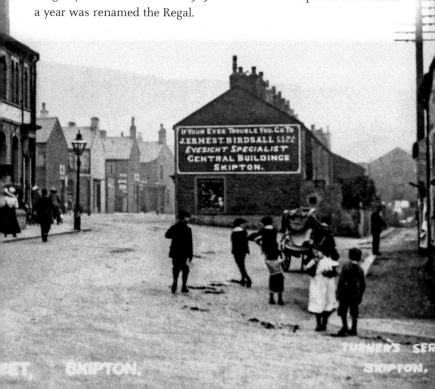

IF YOUR EYES TROUBLE YOU, GO TO
J.ERNEST.BIRDSALL F.B.O.A.
EYESIGHT SPECIALIST
CENTRAL BUILDINGS
SKIPTON.

TURNER'S SER
SKIPTON.

STREET, SKIPTON.

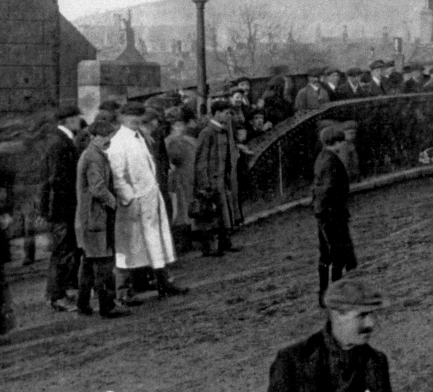

PINDER BRIDGE SKIPTON

ESTING PINDER BRIDGE SKIPT

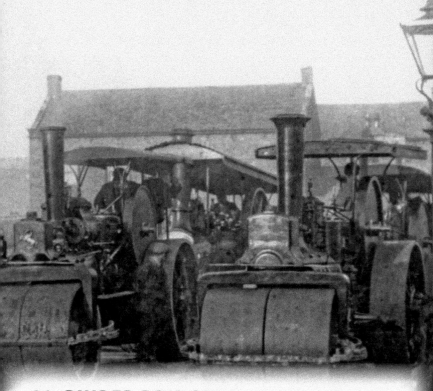

29. PINDER BRIDGE

The visitor to Skipton approaching the town from Keighley around 1908 would have had to cross old Pinder Bridge, which took traffic over the Leeds and Liverpool Canal. 'Clogger' Thompson's shop can be seen on inset photo and notices advertise early films at the Temperance Hall. At only 22 feet wide, it was necessary to demolish and reconstruct Pinder Bridge. The builder was Braithwaite of Leeds and the Clerk of Works was Jim Smith. On 9 November 1910, in front of interested onlookers, three steam rollers and a traction engine were driven over in a public display of its strength.

30. RECHABITES TRIP

As we return over Pinder Bridge, glance to the right and try to imagine this post-First World War scene. Freshly scrubbed coal barges full of children, ready for a trip along the Leeds and Liverpool Canal down to Farnhill. These annual trips were organised by the Rechabites, a temperance society popular in textiles towns who provided sickness and death benefits for those in need. The area to the left was known as Bower's Wharf, named after a Leeds coal merchant who bought the yard in 1863.

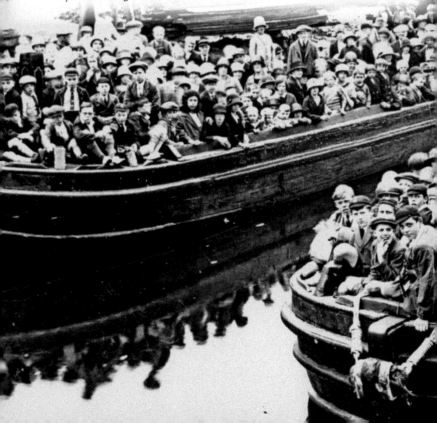

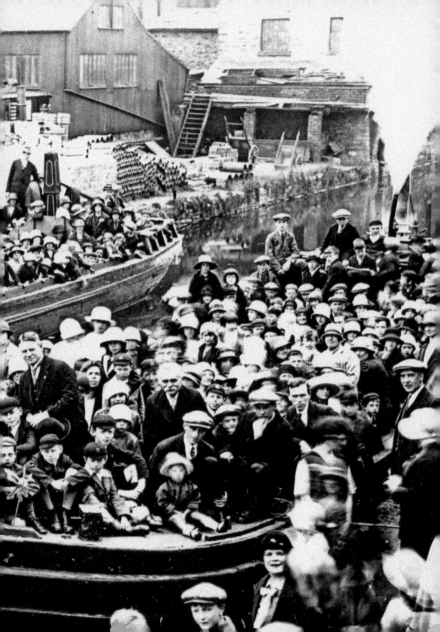

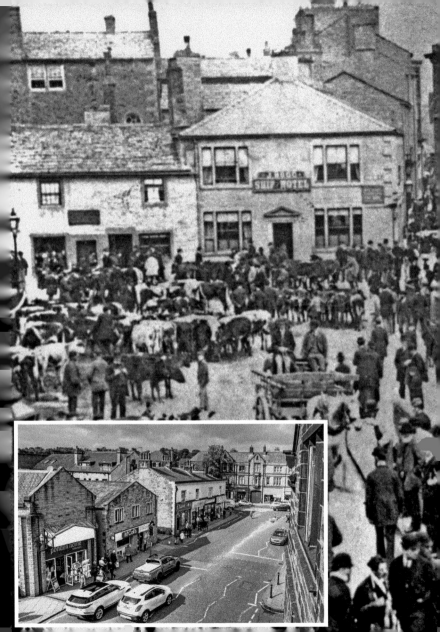

31. UNICORN HOTEL

This elevated photograph by J. H. Smith shows the cattle fair spilling over into Keighley Road. The Ship Hotel is clearly seen and on the right you can see a sloped ramp behind the bridge wall, which slopes towards Waller Hill Beck. When the road was widened and the bridge removed, the beck was culverted under the Keighley Road. Some people have suggested that this constriction contributed to the flooding in this area in 1979 and 1982. The recent image from the 'New' Unicorn Hotel shows how significantly this area has changed in over 100 years.

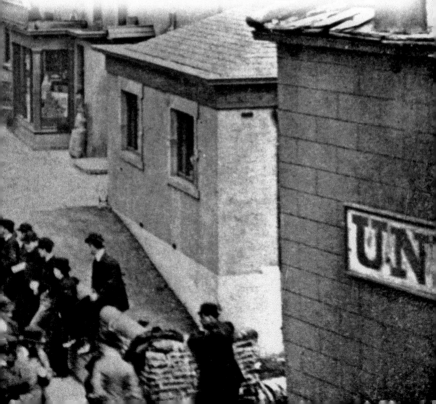

32. WALLER HILL BECK

Here we see the bridge over Waller Hill Beck from a window of the Ship Hotel. This later photograph shows what appears to be steps leading to the beck and no sloped ramp. Just before the entrance to Waller Hill, Mr Walker's cobbler's shop can be seen by the decorative gas lamp. Note the poor condition of the road and a cyclist riding, no doubt trying to avoid horse muck on the road. In the inset image, Mr Walker poses with his young assistant, Evelyn Hall, who walked into work from Carlton each day. A fine display of boots is visible in the window and Mr Walker even kept 'lasts' for his regular boot customers. Waller Hill Beck can be seen on the right having passed under the bridge.

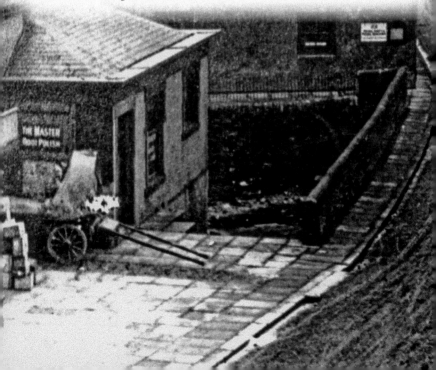

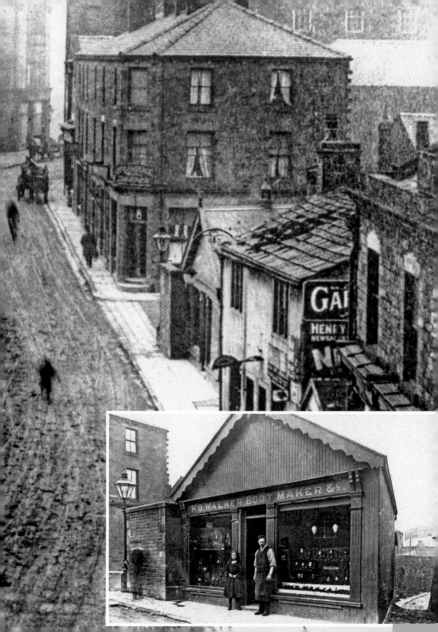

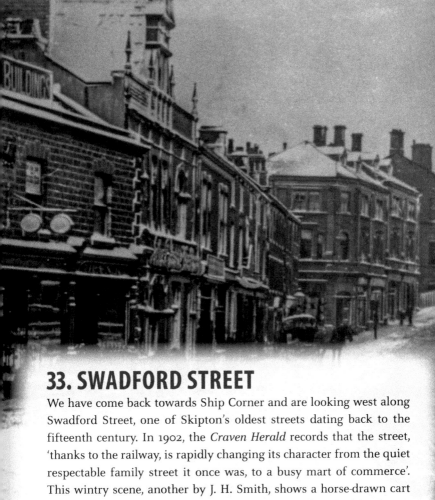

33. SWADFORD STREET

We have come back towards Ship Corner and are looking west along Swadford Street, one of Skipton's oldest streets dating back to the fifteenth century. In 1902, the *Craven Herald* records that the street, 'thanks to the railway, is rapidly changing its character from the quiet respectable family street it once was, to a busy mart of commerce'. This wintry scene, another by J. H. Smith, shows a horse-drawn cart outside Swadforth House, the home and surgery of Mr George Sloane, the dentist. On the right, the sign on the gable end reads 'Chadwick & Co. employ over 1000 Tailors, Cutters and Workpeople'. Behind, the sign reads 'Porri's' which sold china and kitchenware. The name 'Swadforth' probably derives from a former ford across Eller Beck.

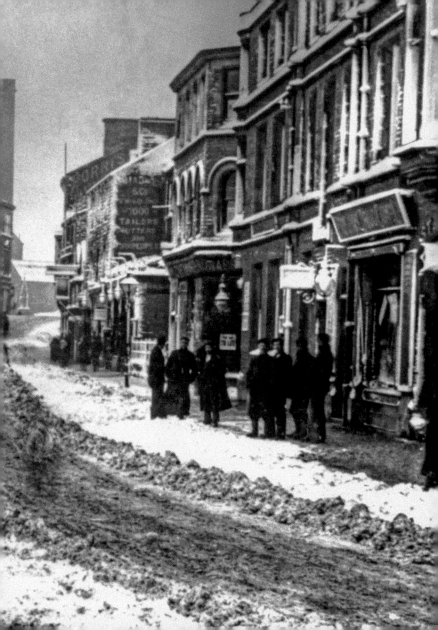

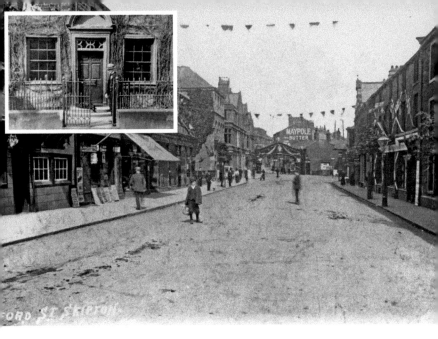

34. SWADFORD STREET

Looking east along Swadford Street toward Ship Corner we can see the coronation arch of George V, giving us the year 1911. This street is full of character on a hot summer's day. On the left we can see the front railings of a beautiful town house that once belonged to Dr Fisher. In 1936 Dr Fisher moved to the Paddock and this old house was reconstructed for Hepworth's clothes shop. The *Craven Pioneer* early in 1937 lamented: 'Skiptonians now know the fate of Swadford, the picturesque family house in Swadford Street. The old homestead, standing back a step or two from adjoining shops, has always been a feature of Swadford Street and was remarkable for its fourteen windows. It was in autumn, however, that it attracted most attention; heavily shadowed in creeper, it brought both colour and beauty to the street'.

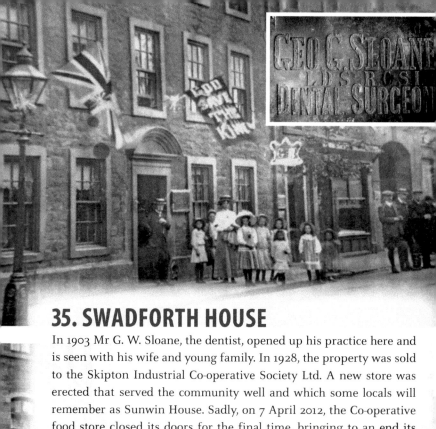

35. SWADFORTH HOUSE

In 1903 Mr G. W. Sloane, the dentist, opened up his practice here and is seen with his wife and young family. In 1928, the property was sold to the Skipton Industrial Co-operative Society Ltd. A new store was erected that served the community well and which some locals will remember as Sunwin House. Sadly, on 7 April 2012, the Co-operative food store closed its doors for the final time, bringing to an end its 150-year association with the town. The George Sloane nameplate was removed and passed onto my father Ken Ellwood when he took over Brian Hargreaves' practice in 1961.

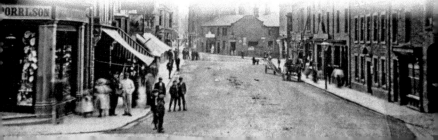

36. BELLE VUE MILL

Handloom weaving was the principal industry in Skipton until the end of the Victorian era. Many of the three-storey houses built in the first half of the nineteenth century were built specifically for handloom weavers. All the houses in Union Square, seen lower right, were built in this fashion. John Dewhurst built Belle Vue Mills in 1828 and it ran for the first time on 17 February 1829 for worsted spinning and weaving wool yarn. This mill was burned down to the ground on 2 January 1831 and rebuilt within a year, now as a cotton mill. In 1852 the mill was greatly extended to hold 385 looms and the newest mill, above left (1867–70) with five storeys, was 225 feet in length and over 70 feet wide. The entire premises of 'Dewhursts' had a floor space area of 20,000 square yards and more than 800 operatives were in continual employment engaged in the spinning and weaving of cotton. Dewhursts became 'The Home of Sylko', a brand fondly remembered and Skipton's main employer for decades. In 1888, the family business was converted to a private limited company, John Dewhurst & Sons Ltd, and in 1897 fourteen firms combined to form the English Sewing Cotton Co. Ltd., which is as it remained until 1983, when the company announced that they were closing their operation with the loss of 240 jobs. The mill buildings were sold to Kinglsey cards, who subsequently went into administration in 2006 and the old mill was finally converted into a complex of flats and offices, including the Craven District Council. Of interest on the left of this photograph is the Auction Mart, which was originally founded in 1886, and the Cottage Hospital (top right), which was opened on the very last days of the nineteenth century. The lower two images opposite are a Smith photo capturing the scene of flooding near Belmont Wharf on 3 June 1908 and a similar view taken in 2018.

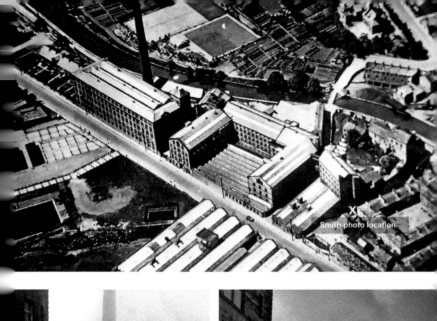

X
Smith photo location

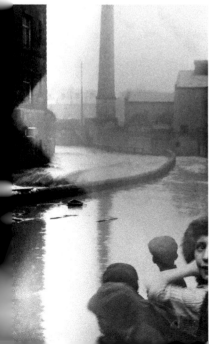

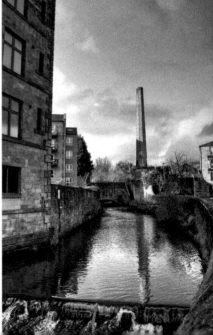

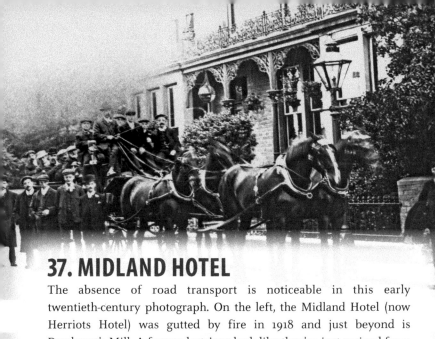

37. MIDLAND HOTEL

The absence of road transport is noticeable in this early twentieth-century photograph. On the left, the Midland Hotel (now Herriots Hotel) was gutted by fire in 1918 and just beyond is Dewhurst's Mill. A few pedestrians look like they've just arrived from the station are walking parallel to what used to be the stationmaster's house, built in 1875 and concealed by the trees. This was demolished to make way for the new fire station, which moved from the side of Coach Street in 1975. Above is an earlier photograph showing a handsome horse-drawn carriage, possibly on an outing from the Midland Hotel.

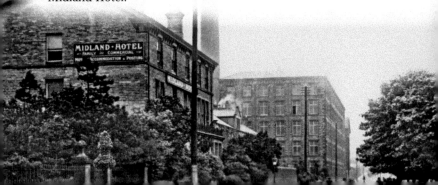

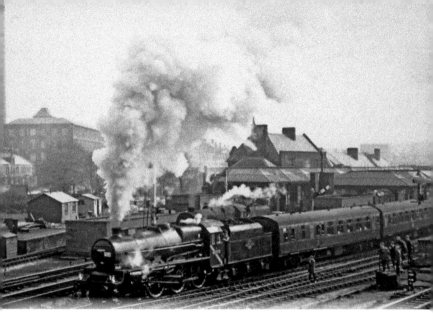

38. SKIPTON RAILWAY STATION

Further down Broughton Road we reach Skipton railway station, which was relocated from its original site (Tesco supermarket) in April 1876. Here we see London Midland and Scottish Jubilee Class 4-6-0 No. 45592 *Indore* leaving platform 4 on the Settle Carlisle line. Interested onlookers record the decline of steam at the end of the 1960s. Below, a Ken Ellwood photograph showing LMS Class 8P 'Coronation' No. 44629 *Duchess of Hamilton* leaving Skipton during a railtour to Carlisle in July 1996.

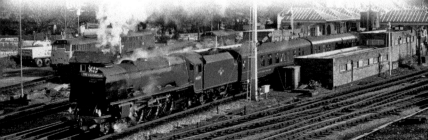

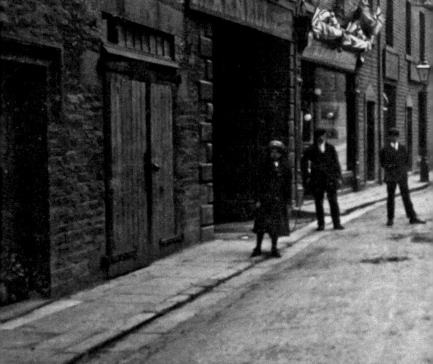

·LON[C]

COACH S[t] SKIPTON CORONATION

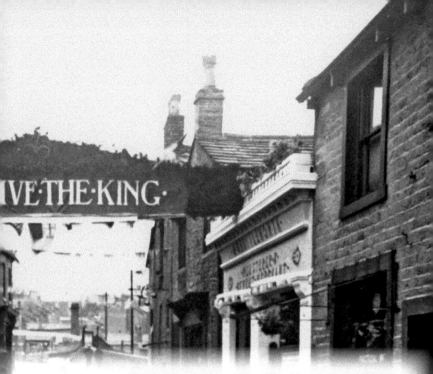

IVE·THE·KING·

39. COACH STREET

Just along Coach Street from Swadford Street we see another arch in celebration of the coronation of George V in 1911. On the left is the shop of T. Farnell, described in 1907 as a 'general and artistic wood carver'. The shop is now a unisex hair salon called Reflection. The building on the right, with the ornately decorated white front, was demolished and is now Albert Terrace. Of particular note is that Mr H. C. Foster learned his trade as a wood carver and picture framer from Mr Farnell and took over the business before moving to premises across the road. Mr Foster retired in 1961 and some of his work can be seen in the chapel of Skipton parish church.

GEORGE V. 1911.

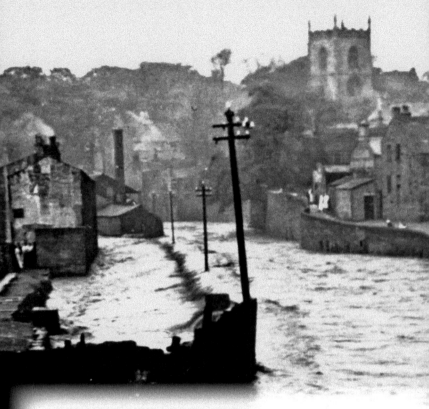

40. THE SPRINGS CANAL

From Coach Street, we reach 'New Bridge', which overlooks the Springs Canal, one of my favourite views in Skipton. The image shows the Springs Canal during the great flood on 3 June 1908 when the Round Dam burst its banks following a severe storm. A severe cloudburst stretched from Crookrise to Embsay Crag and caused a tremendous flow of water at the two converging becks in Skipton Woods to break through the dam into the canal. A more tranquil summer scene is apparent in this recent photograph, taken in 2017.

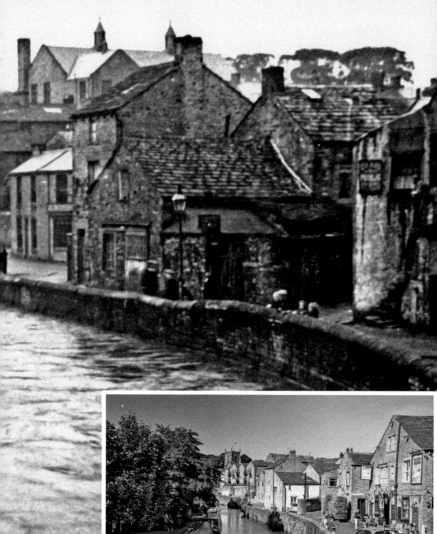
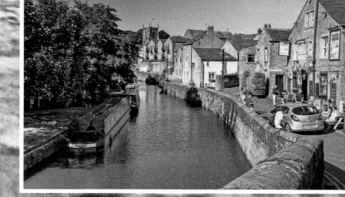

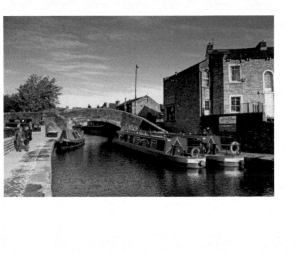

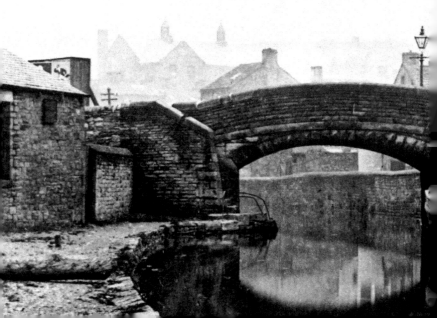

41. THE CANAL BASIN

This section of the Springs Canal was constructed in 1773 to transport limestone from Lord Thanet's quarry at the back of Skipton Castle to the Leeds and Liverpool Canal. The canal had a great impact on the industry and life of Skipton and was a significant factor in the development of the town's numerous cotton mills. Although construction of the canal had begun in 1770, it was not until October 1816 that the Leeds and Liverpool Canal was opened along its entire length. The town celebrated the bicentenary of both events in 1973 to mark the completion of the section between Skipton to Bingley and in 2016 a re-enactment of the first crossing from Leeds canal basin to Liverpool, featuring *Kennet*, the historic short boat.

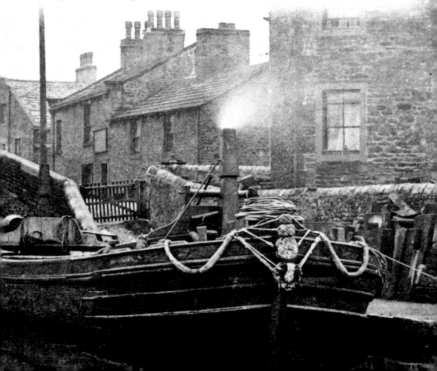

42. THE DOCKYARD

From the canal basin we pass the 'Old Fire Station', now aptly named the 'Fashion Station'. At the back is a rather welcoming micro bar called 'The Mess Room' so if you've time, why not try one of their craft beers? The car park was once this area extending towards Brook Street known as the Dockyard. Skipton Cottage Hospital can just about be made out in the distance on the left side of Granville Street. The astonishing flood of 1908 caused severe overflow in a number of areas, including this one. Locals and visitors alike came from all around to witness these incredible scenes.

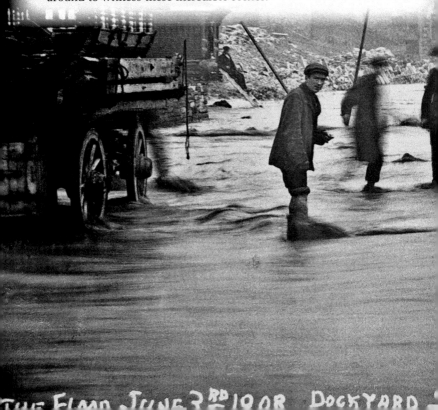

THE FLOOD JUNE 3ᴿᴰ 1908 DOCKYARD

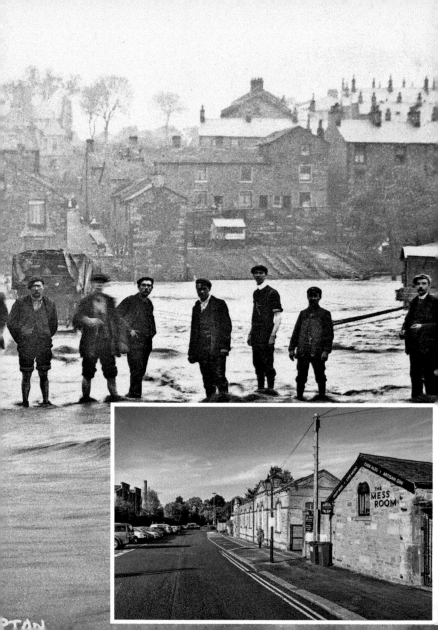

43. ST STEPHEN'S CATHOLIC SCHOOL

St Stephen's Roman Catholic School dates back to 1854, when it was built at the foot of the hill on Gargrave Road in response to the needs of Skipton's growing Catholic community. Over sixty years ago work to incorporate Holywell Cottage at the rear was hindered by a 40-foot-deep well in the cottage cellar. It is believed the cottage was built over the well, and in the early 1820s this cottage and the Woodman Inn further up the road were the only buildings in the vicinity before the Skipton to Kendal highway was built in 1824. The buildings have recently been converted into a number of apartments and family homes by Skipton Properties. I wonder what became of the well...

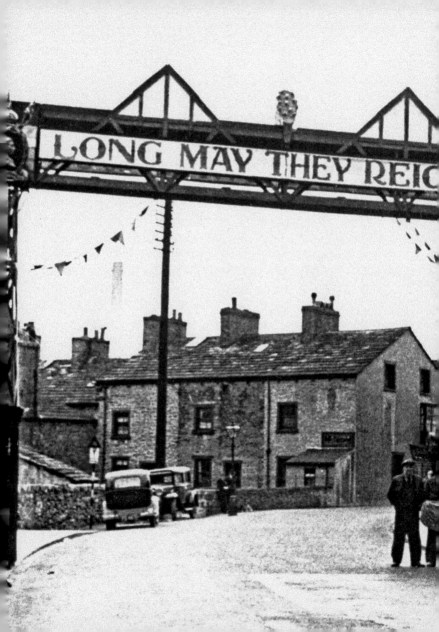

44. WATER STREET

Water Street at the time of the Coronation of King George VI in 1936. Images of George VI and Queen Elizabeth Bowes Lyon can be seen on the specially erected Coronation Arch. Interested spectators gather in front of A. Shuttleworth & Son fireplace specialists, a business that occupied these premises for many years and from 1974 to 1998 by Mr Norman Cook and Mr George Mason. T. N. Cook Ltd continues the tradition as 'the place to go for everything range cooking' at Close House Farm on Otley Road. The building is now a supplier of school uniforms and sportswear, appropriately named 'Skip to School'. In the background is a view of Lower Commercial Street, which was demolished in around 1964 to make way for the car park opposite the 'Old Fire Station'. Dewhursts Mill chimney can be seen on the left and the Commercial Inn, now Kong's Cantonese restaurant, is on the right.

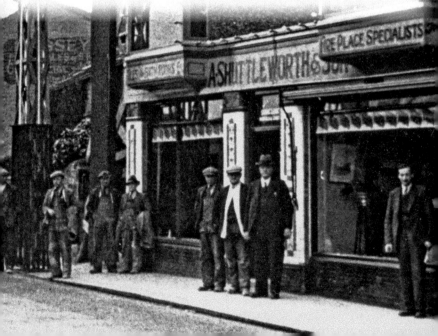

45. WESLEYAN CHAPEL

Built at a cost of just £4,000, one of Skipton's finest buildings was built on Water Street in 1864. The building was constructed for the Wesleyan Methodist Church to seat 900 people and was sold some 148 years later by North Yorkshire County Council for approximately £375,000, when the council relocated to its new home at Belle Vue Square. In 1932, the Wesleyan Methodists merged with the Primitive Methodists who had moved to a new location on Gargrave Road from Coach Street. I remember it as a rather gloomy-looking building, knocked down in 1976 to make way for flats. The Methodist Union would eventually see the closure of the Water Street Chapel, which held its last service on 31 August, 1952. The building was sold to the

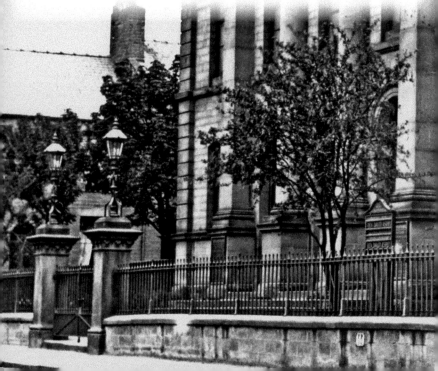

West Riding County Council for £7,500 and it was refurbished and served as the headquarters for the Youth, Employment and Education Service until 2010. In 2015, it celebrated its 150th anniversary and in October of that year, the *Craven Herald* reported the sale of the building came with a number of conditions: 'that under no circumstances was it to be used as a drinking establishment, or be turned into a boxing venue, a gambling joint or heaven forbid, Skipton's first lap dancing club. In fact, it could not be used for anything that could potentially cause a nuisance.' The building was duly sold, renovated, and is now offices. So far 'it has not caused a nuisance to anyone'.

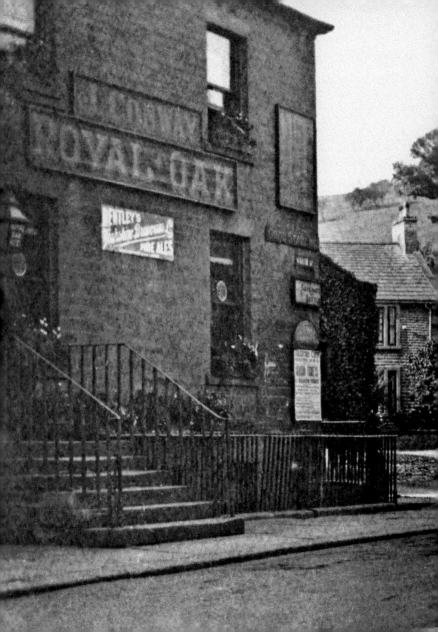

46. CHAPEL HILL

The view looking towards Chapel Hill outside the Royal Oak, now Ackroyds Wine Bar, has changed little since it was captured in the early 1900s. The poster above the railing advertises season tickets for Bradford City, founded in 1903. Difficult to imagine now, but when the Royal Oak was built, the road in front was much lower and the front door was underneath the steps. The canal branch was not there and the beck came over the road creating a ford and a steep hill from Raikes Road up toward the church. A good circular walk for visitors is up Chapel Hill behind the uniformed gentleman, over Park Hill and back through Skipton Woods via the Long and Round dam.

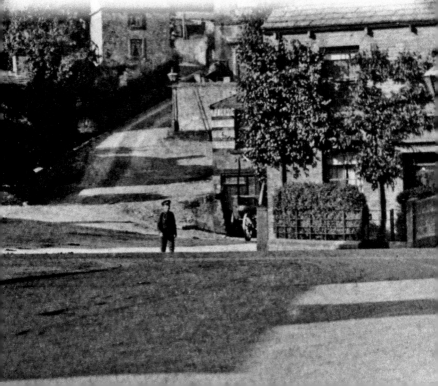

47. ROUND DAM

A walk along the Springs Canal and into Skipton Woods is one of Skipton's hidden gems. Hidden behind the castle and within minutes of Skipton's busy High Street, you can soon be in the tranquil surroundings of this popular beauty spot for both locals and visitors. This rare and ancient woodland habitat is beautifully maintained by the Woodland Trust and a great place to explore with the family. This tinted postcard, another by Smith, shows the Round Dam area possibly before the devastating flood of 1908. The Long Dam and Round Dam were formerly part of the water system for the High Corn Mill, which can be seen easily from Mill Bridge. I took this winter scene of the Round Dam area when the water was frozen and after a light sprinkling of snow in January 2017.

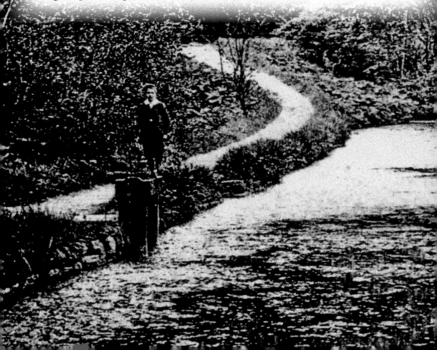

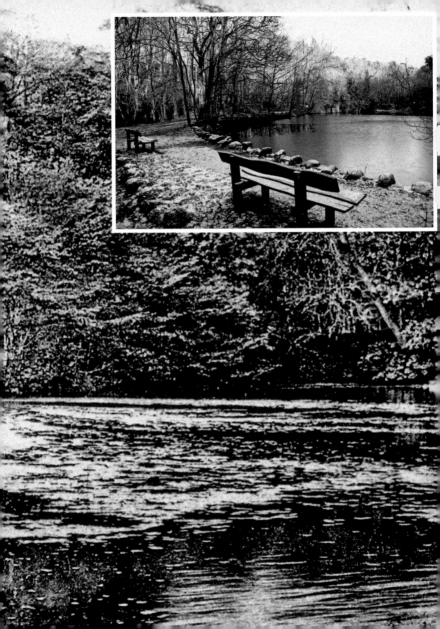

48. MILL BRIDGE

Mill Bridge is actually two bridges. Eller Beck flows under the bridge where the boy has climbed up the lamp post and further up, an arch bridge crosses the Leeds and Liverpool Canal, below which you can see where the original bridge was widened as part of road improvements. It is thought that this road was a narrow track crossed by a stream level with the Old Ship Inn leading up a steep incline to the church wall. In this 1908 photograph, we can see houses that were demolished in 1956 and may give you an idea of the original ground level. This is now a pleasant garden area with a footpath that leads up the Springs Canal behind the high crag on which Skipton Castle was built. The willow trees were planted by Mrs Gwynne Walters, who was a prominent member of the Civic Society.

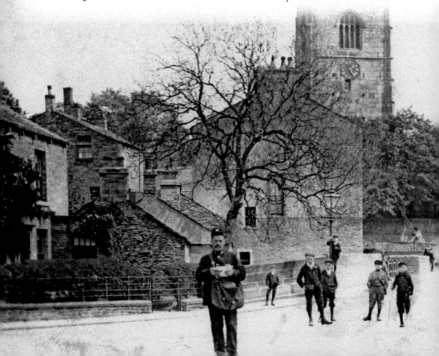

49. THE NEW SHIP

The New Ship Inn is believed to be another one of Skipton's oldest landmarks. Standing by the door is Mr John Alderson, an auctioneer and valuer, and husband to the licensee, Mrs Margaret Alderson, second from the left. From 1907 various attempts were made to declare the licence redundant. The challenge was resisted by reason of 'Tenancy of 120 years handed down from generation to generation with an unblemished reputation'. In 1911, a third attempt to close down the inn prompted the *Craven Herald* to say of Mrs Alderson: 'There is probably not another instance in Skipton, if in Yorkshire, where the tenant of an old fashioned hostelry can say she was born in the house, brought her family up in it, and buried her husband from it'. John Alderson died in 1908, the same year this photograph was taken.

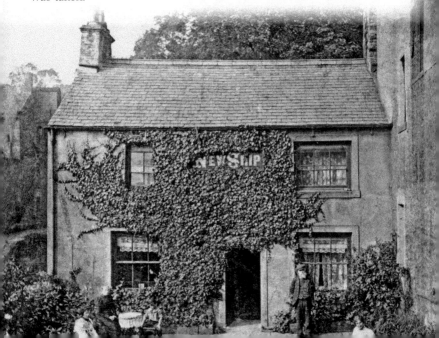

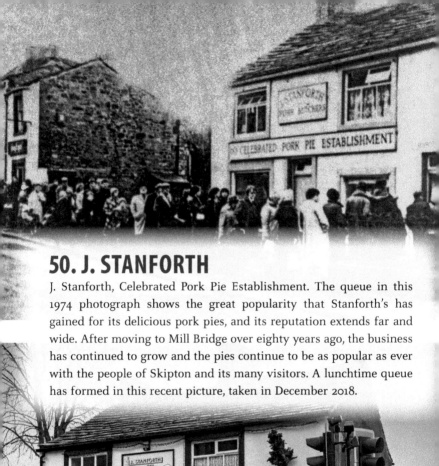

50. J. STANFORTH

J. Stanforth, Celebrated Pork Pie Establishment. The queue in this 1974 photograph shows the great popularity that Stanforth's has gained for its delicious pork pies, and its reputation extends far and wide. After moving to Mill Bridge over eighty years ago, the business has continued to grow and the pies continue to be as popular as ever with the people of Skipton and its many visitors. A lunchtime queue has formed in this recent picture, taken in December 2018.

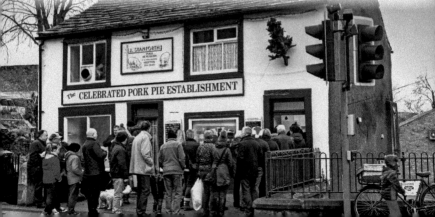

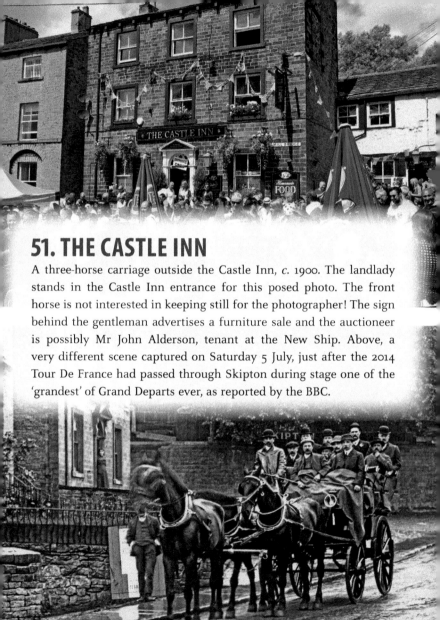

51. THE CASTLE INN

A three-horse carriage outside the Castle Inn, *c.* 1900. The landlady stands in the Castle Inn entrance for this posed photo. The front horse is not interested in keeping still for the photographer! The sign behind the gentleman advertises a furniture sale and the auctioneer is possibly Mr John Alderson, tenant at the New Ship. Above, a very different scene captured on Saturday 5 July, just after the 2014 Tour De France had passed through Skipton during stage one of the 'grandest' of Grand Departs ever, as reported by the BBC.

52. MILL BRIDGE

As we return to the parish church on this history tour, head up the church yard steps to get this view of Mill Bridge and the lower part of Raikes Road. This was the scene here 111 years ago, showing Skipton's celebratory procession of George V's coronation on 22 June 1911. The buildings are much the same today as we look towards the Royal Oak, and on the left is a confectionery shop selling Fry's Chocolate. A tobacconist is selling various tobacco brands including 'Coolie Cut Plug', 'Midnight Flake' and 'Sportsman mixture'. How times have changed, but some views of Skipton will always remain the same.

ACKNOWLEDGEMENTS

Perhaps the person who I should thank the most is my father, Ken Ellwood, who during his time in Skipton started collecting old photographs of the town and its surrounding areas. As a well-known dentist situated above the lower part of the High Street overlooking Caroline Square, he was well placed to come into contact with a large cross section of the Skipton community, who were only too pleased to help by loaning him old photos and providing him with interesting tales. As his interest grew, and greatly encouraged by his friend Dr R. G. Rowley, between them they amassed a collection of old photographs now held at the Skipton Public Library called the Rowley Ellwood Collection.

Many of the photographs used in this book are from this collection and in some cases lovingly restored to bring out some important details. This has been very useful when dating each of the photographs.

Many of the images collected by both my father and Dr Rowley were copied from original negatives by another friend, Frank Knowles, who worked in the photographic department at Leeds General Infirmary. Frank was able to make excellent prints and produce multiple copies during a forty-year period in which my father actively collected. When Dr Rowley died in 1987, his wife Val Rowley

continued to collect, and copies of slides were made and donated to both the Skipton Library and the Craven Museum.

My thanks go to Skipton Public Library for assistance in locating specific photos and allowing me to recopy some of the old photos. Also to Ian Lockwood, former editor of the *Craven Herald*, whose excellent book *The History of Skipton* has been a vital source of research. Thanks also go to Richard Fattorini, a former resident of Skipton Castle, for providing me with information about J. H. Smith, the prolific photographer who captured many of the key events in Skipton's history at the beginning of the twentieth century. I am grateful to Tony Harman, of Maple Leaf Images, for his expertise in rescanning and copying slides and photographs, and also the Rowley Ellwood website, which now features Dr Rowley's handwritten notebooks, with fascinating details on Skipton's history. I should also thank my brother, David Ellwood, for his assistance in locating photographs.

I should also acknowledge the generous people of Skipton, many of whom are no longer with us, who have loaned out original photographs and negatives so that duplicates could be made to form this substantial collection of images.